Hot Sexy Black Lingerie Girls Models Pictures

By **EROTICA PHOTO ART LOVER**

Copyright © Black Girls

All rights reserved. No part of this document may be
Reproduced or transmitted in any form or by any means, electronic, mechanical, photocopying,
Recording, or otherwise, without prior written permission of erotica photo art lover.

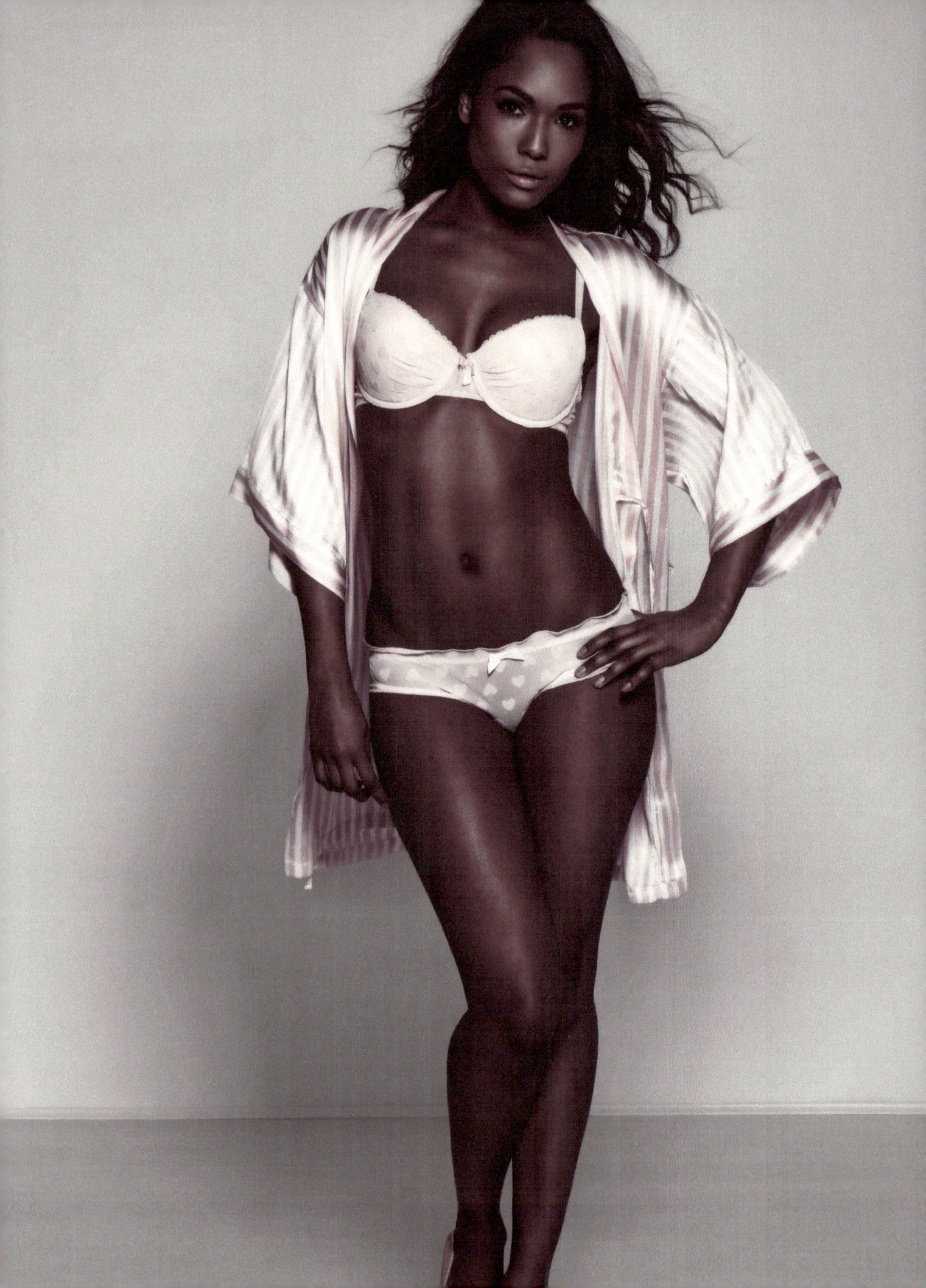

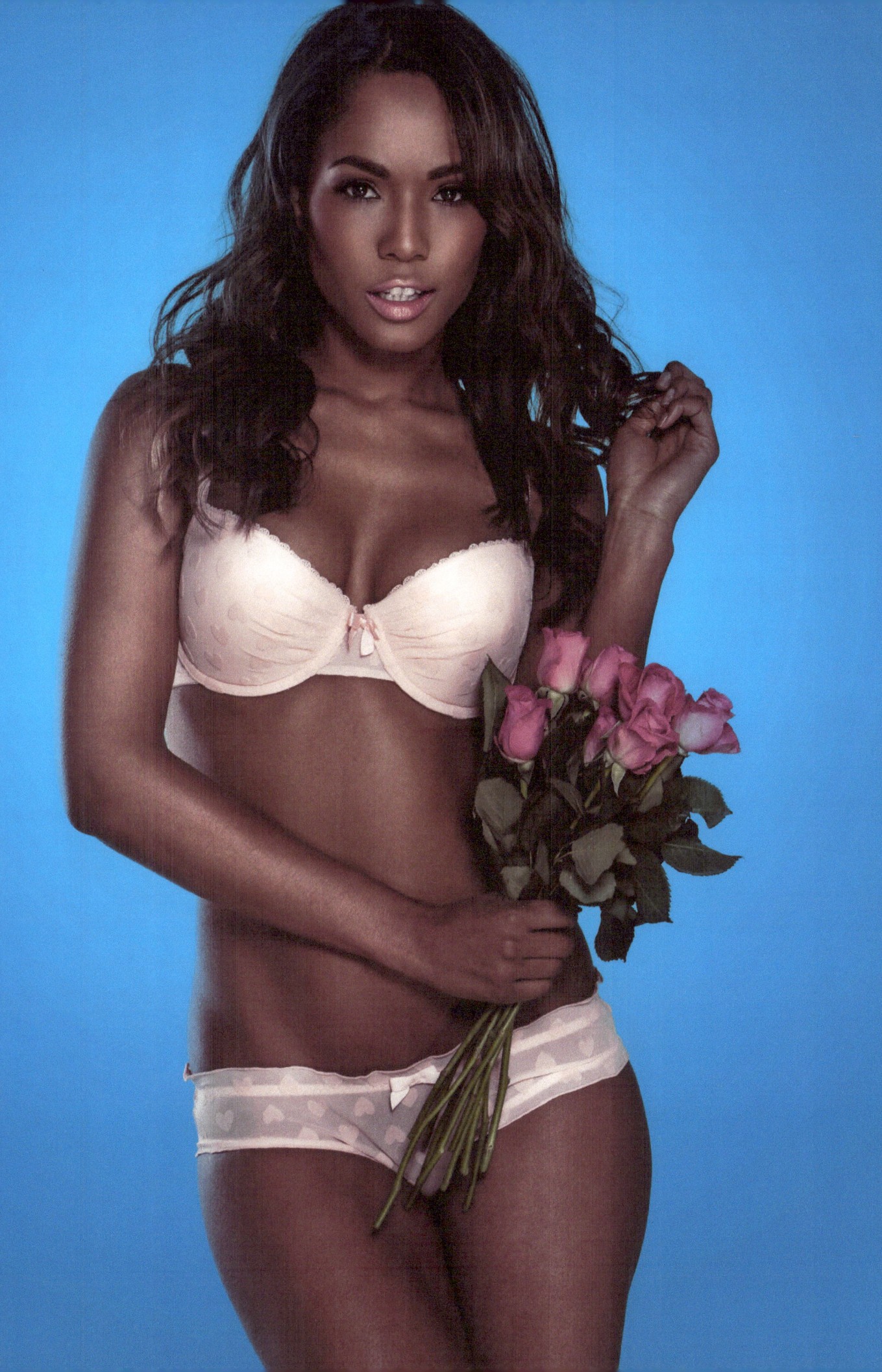

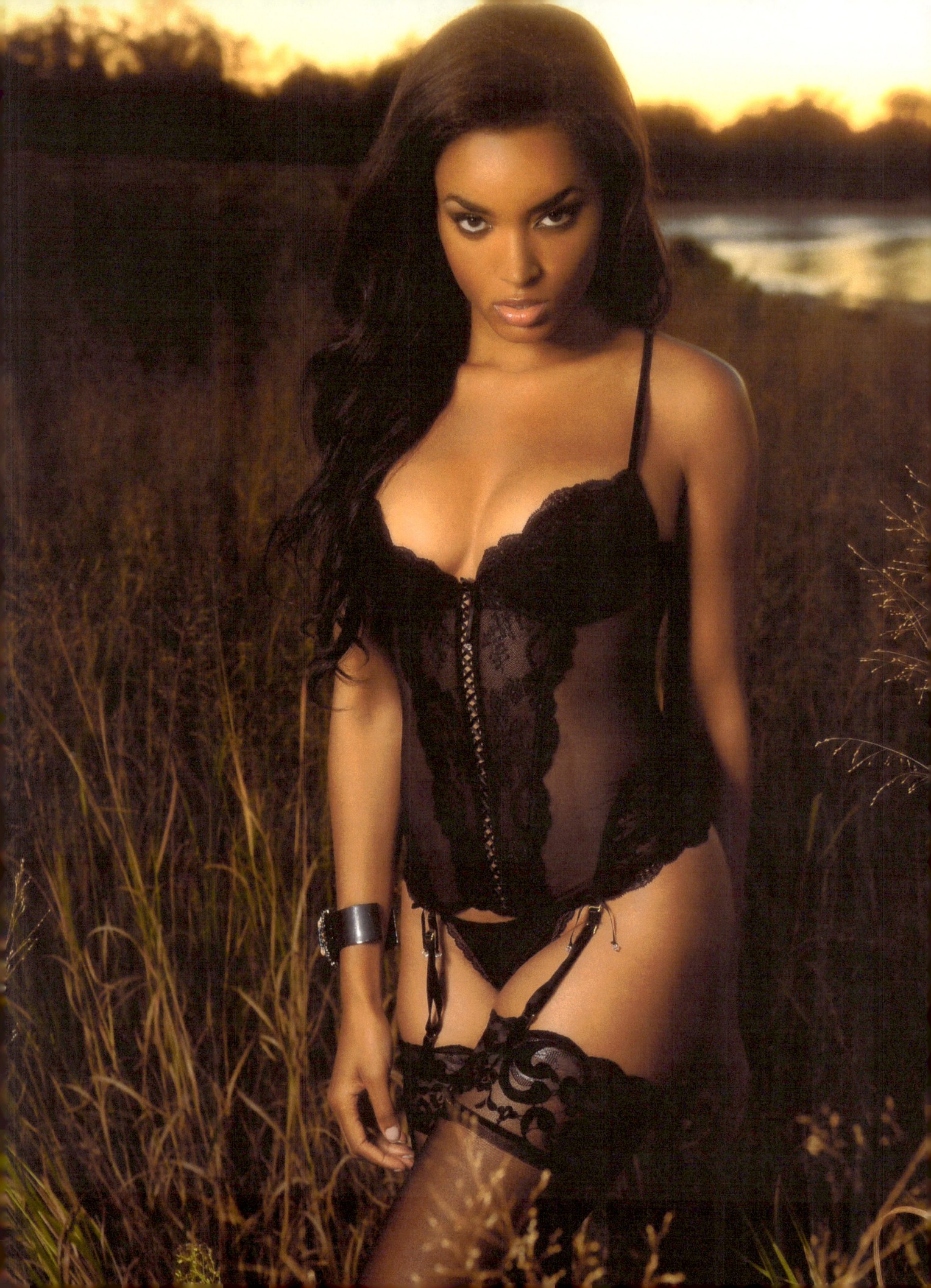

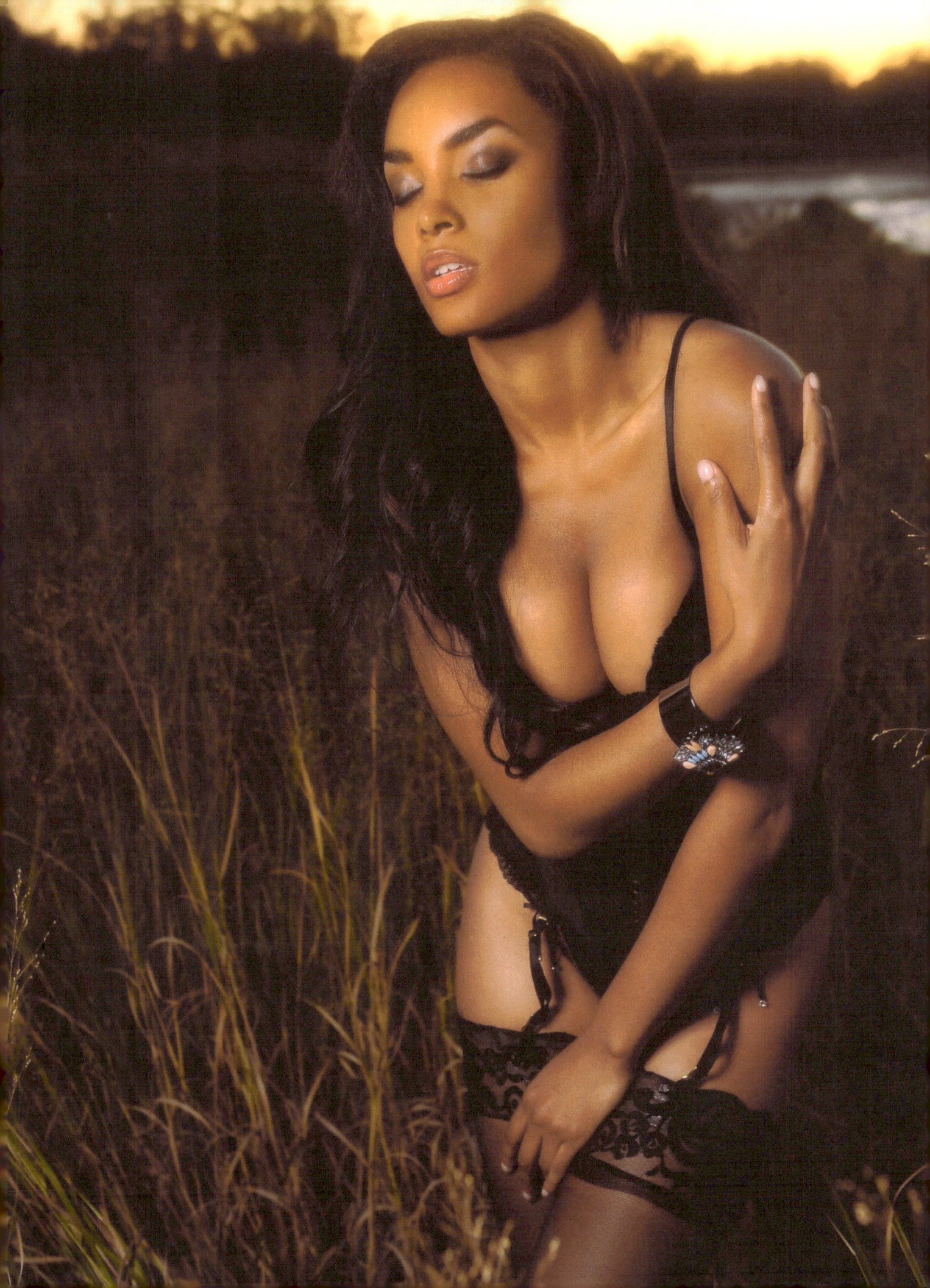

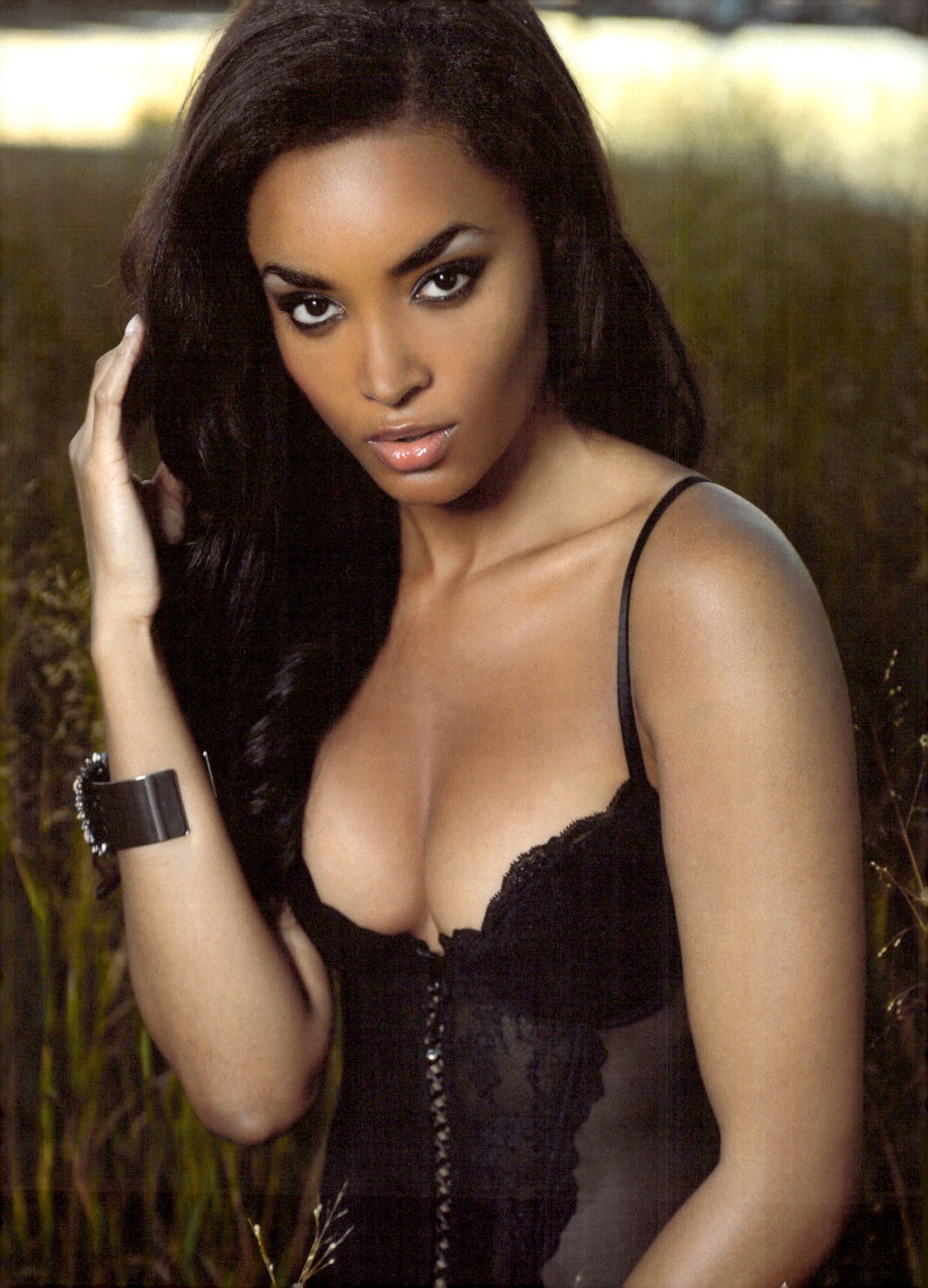

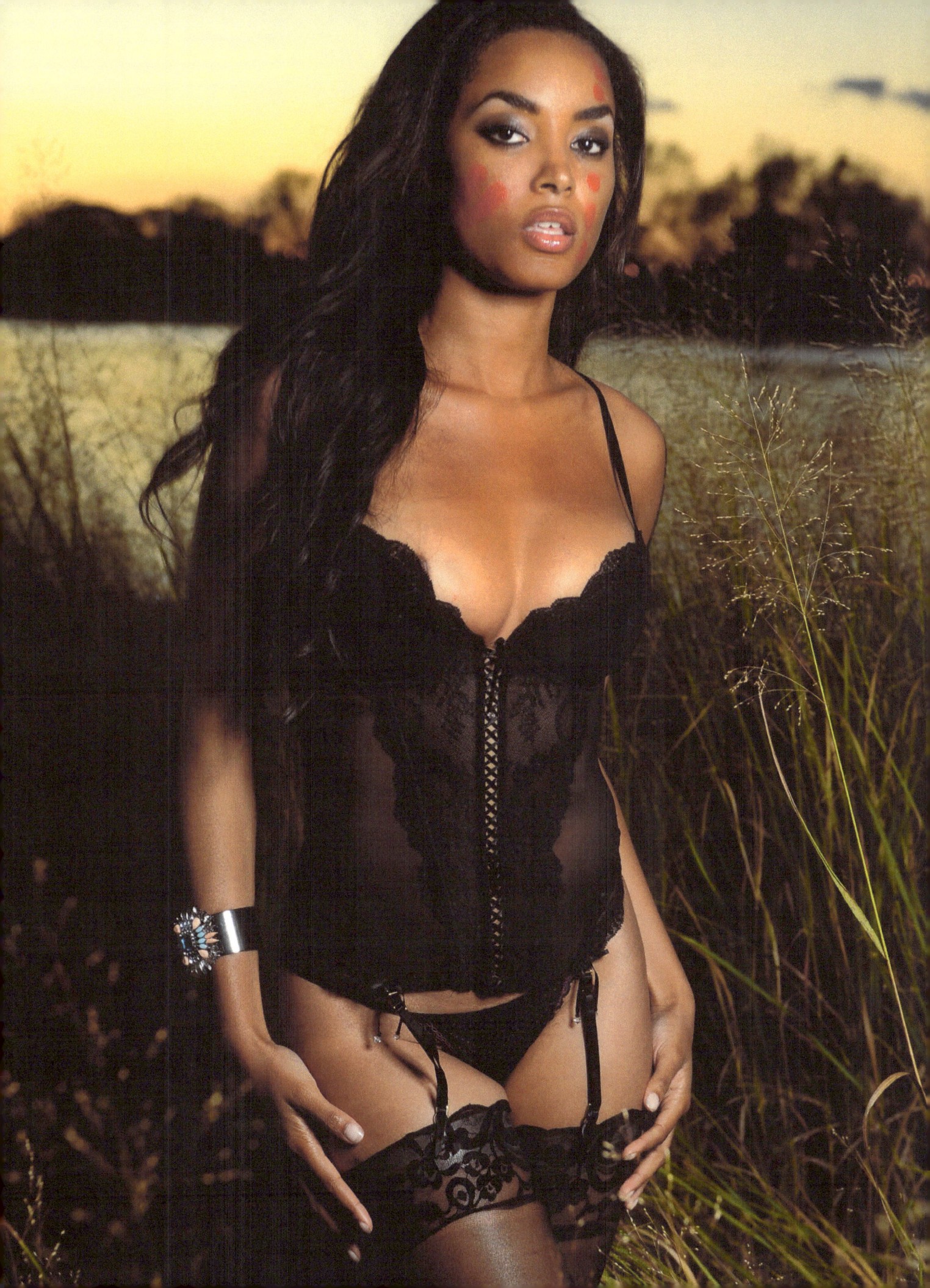

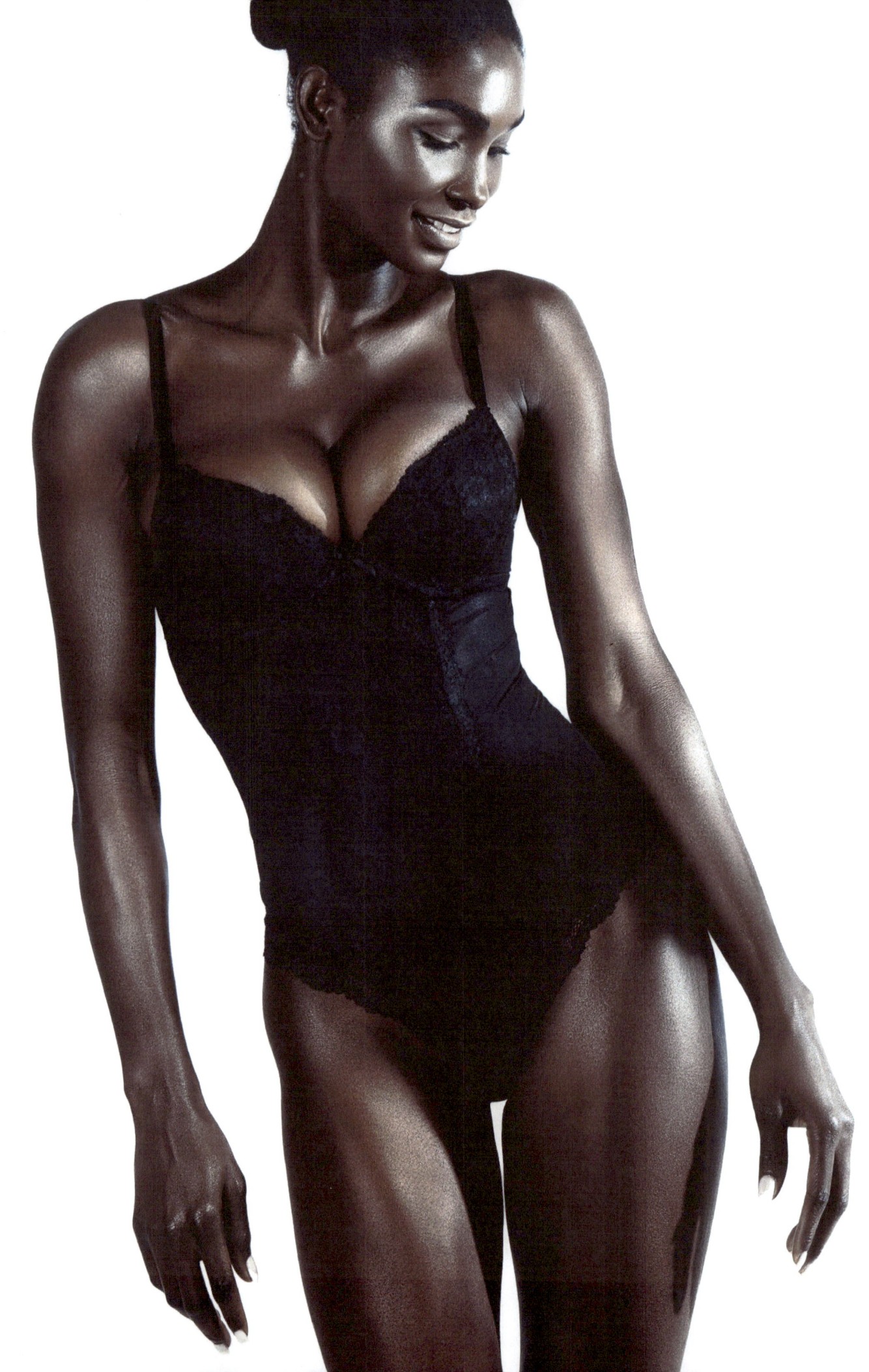

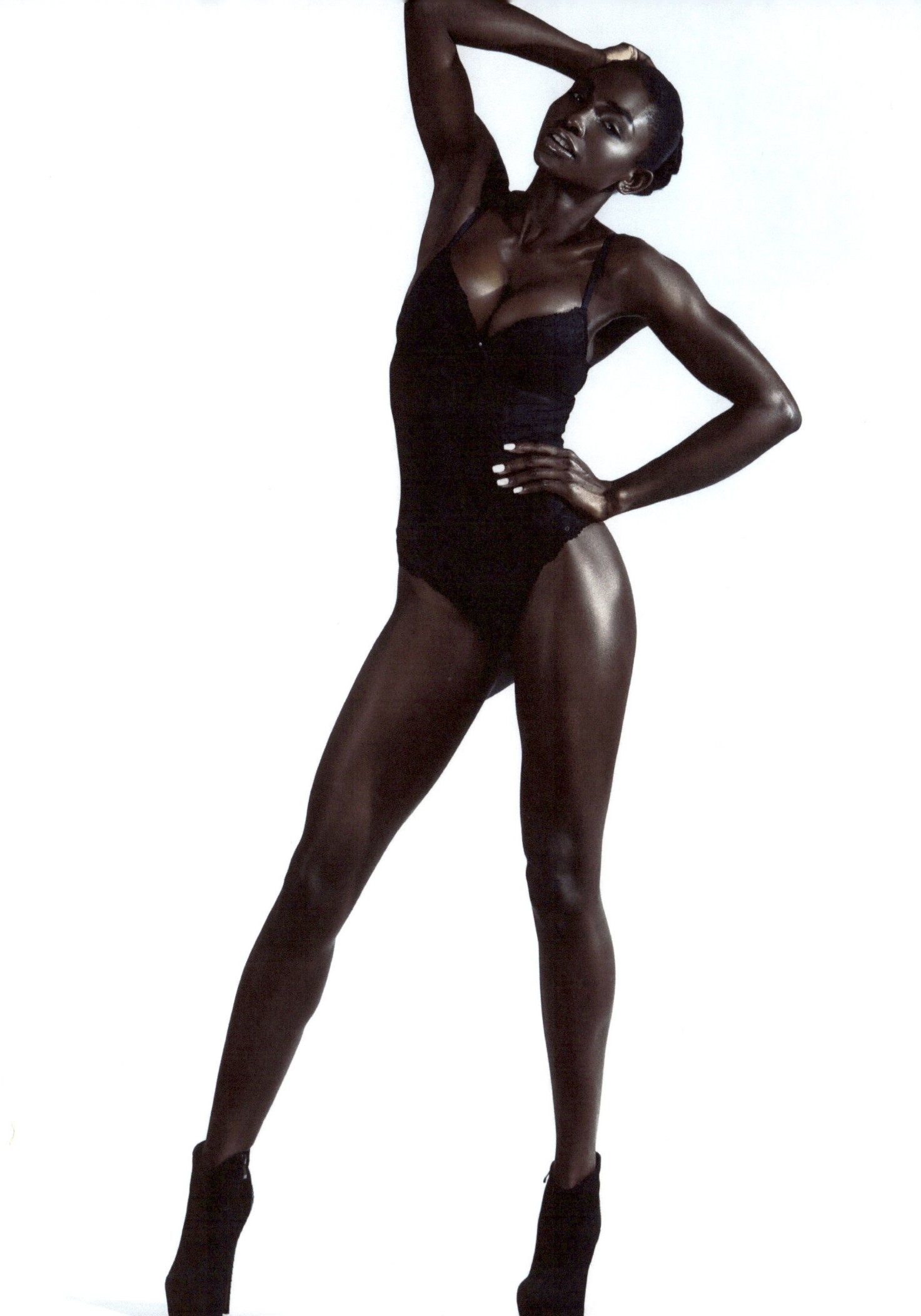

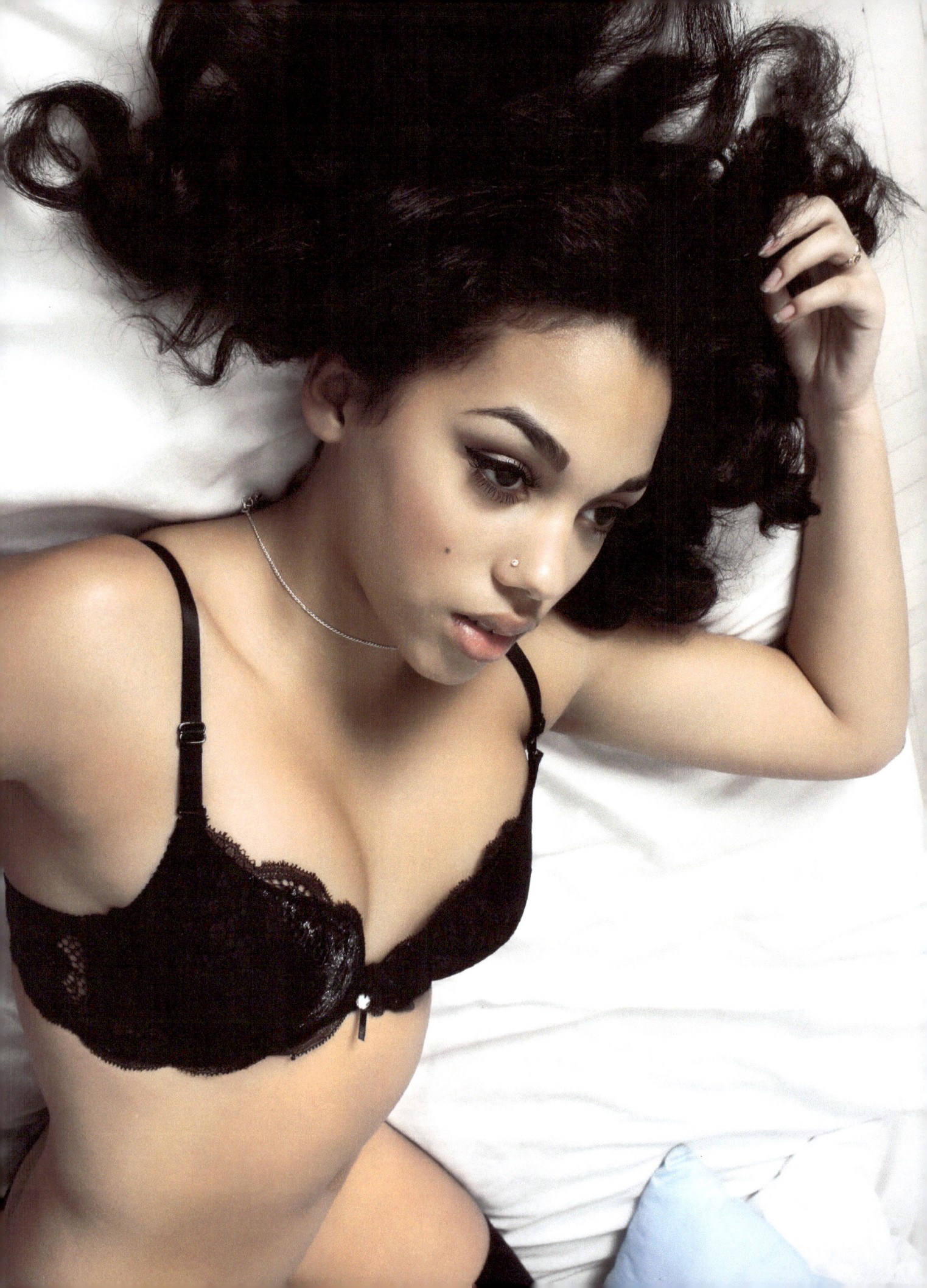

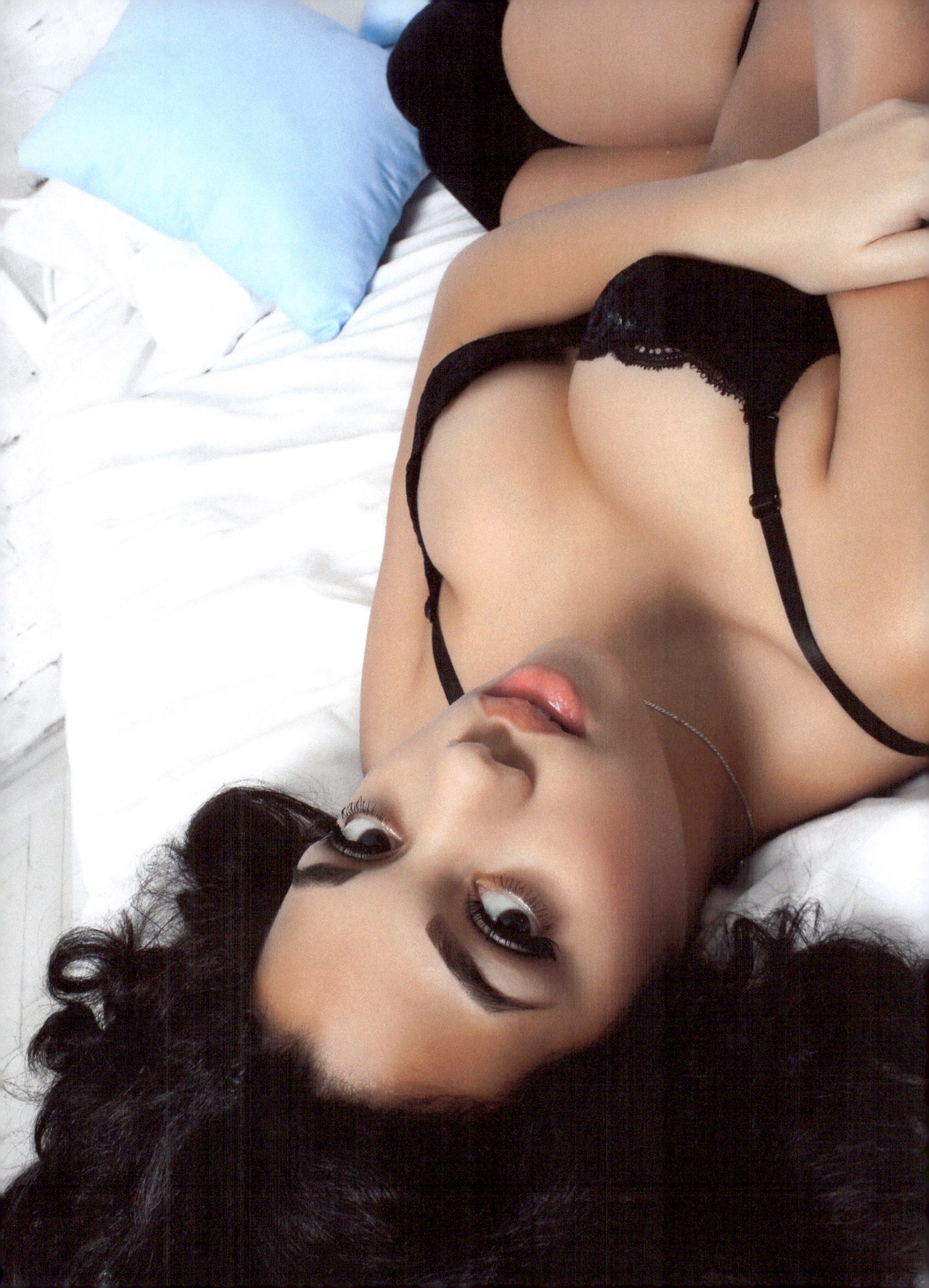

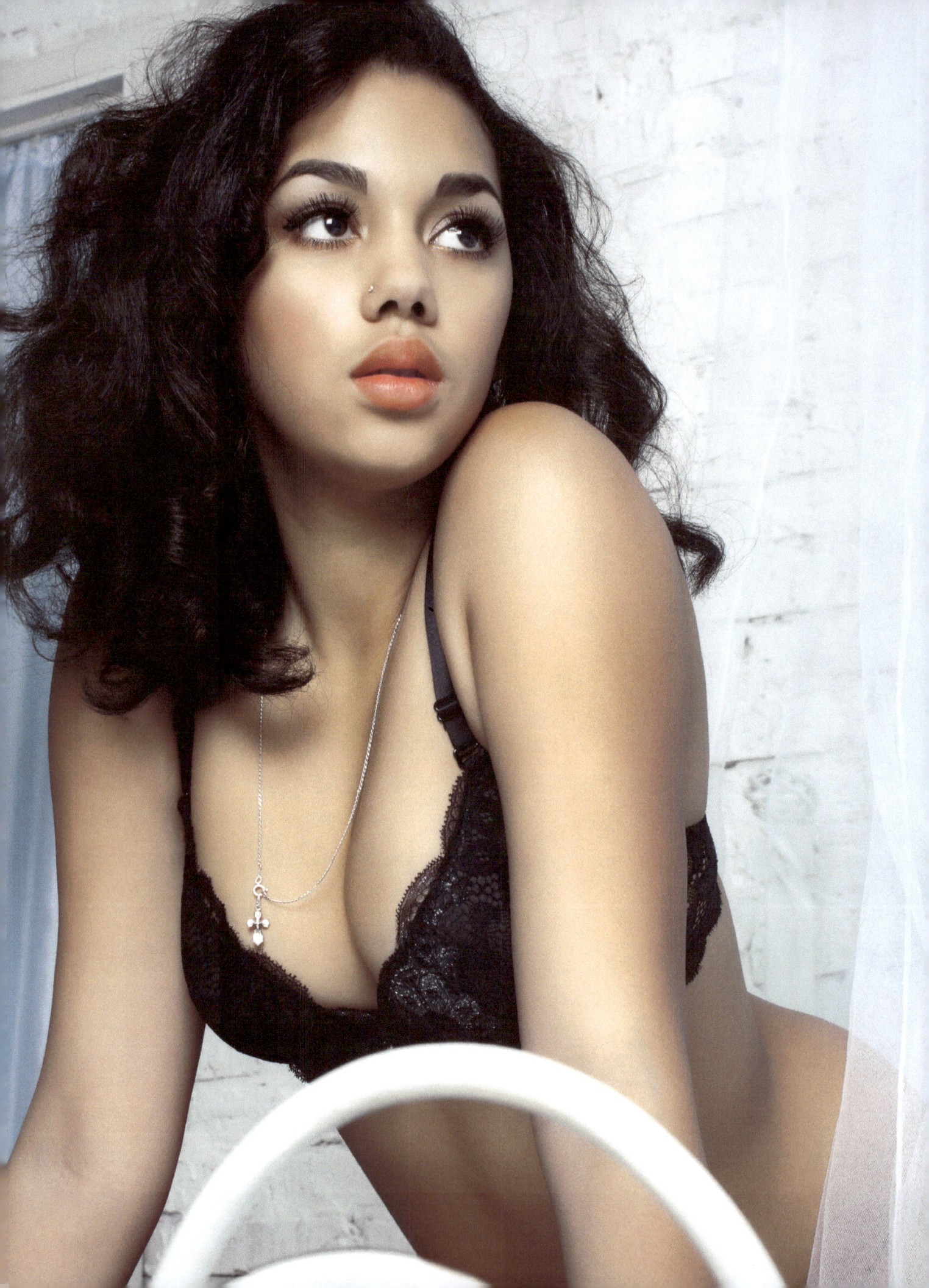

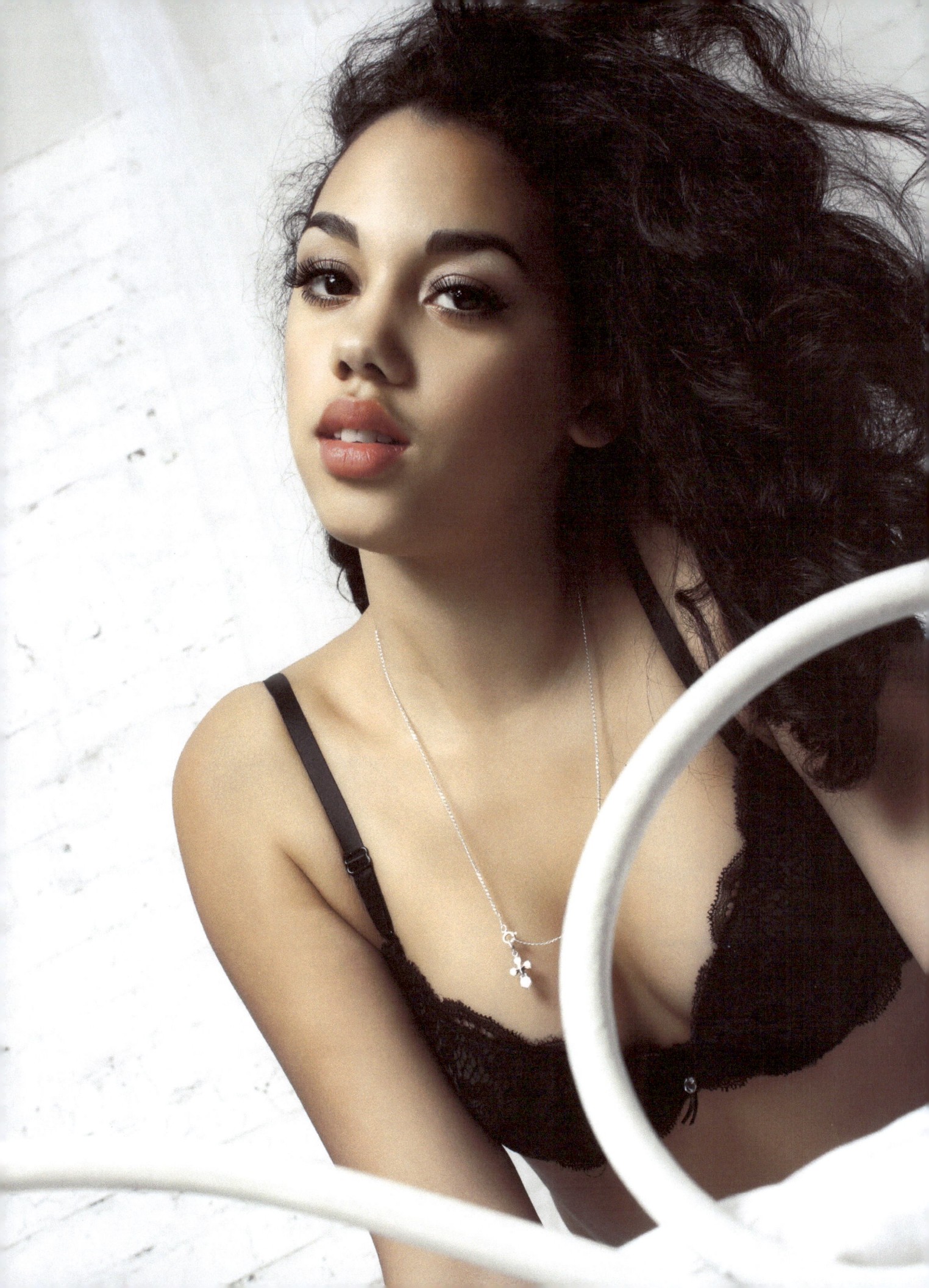

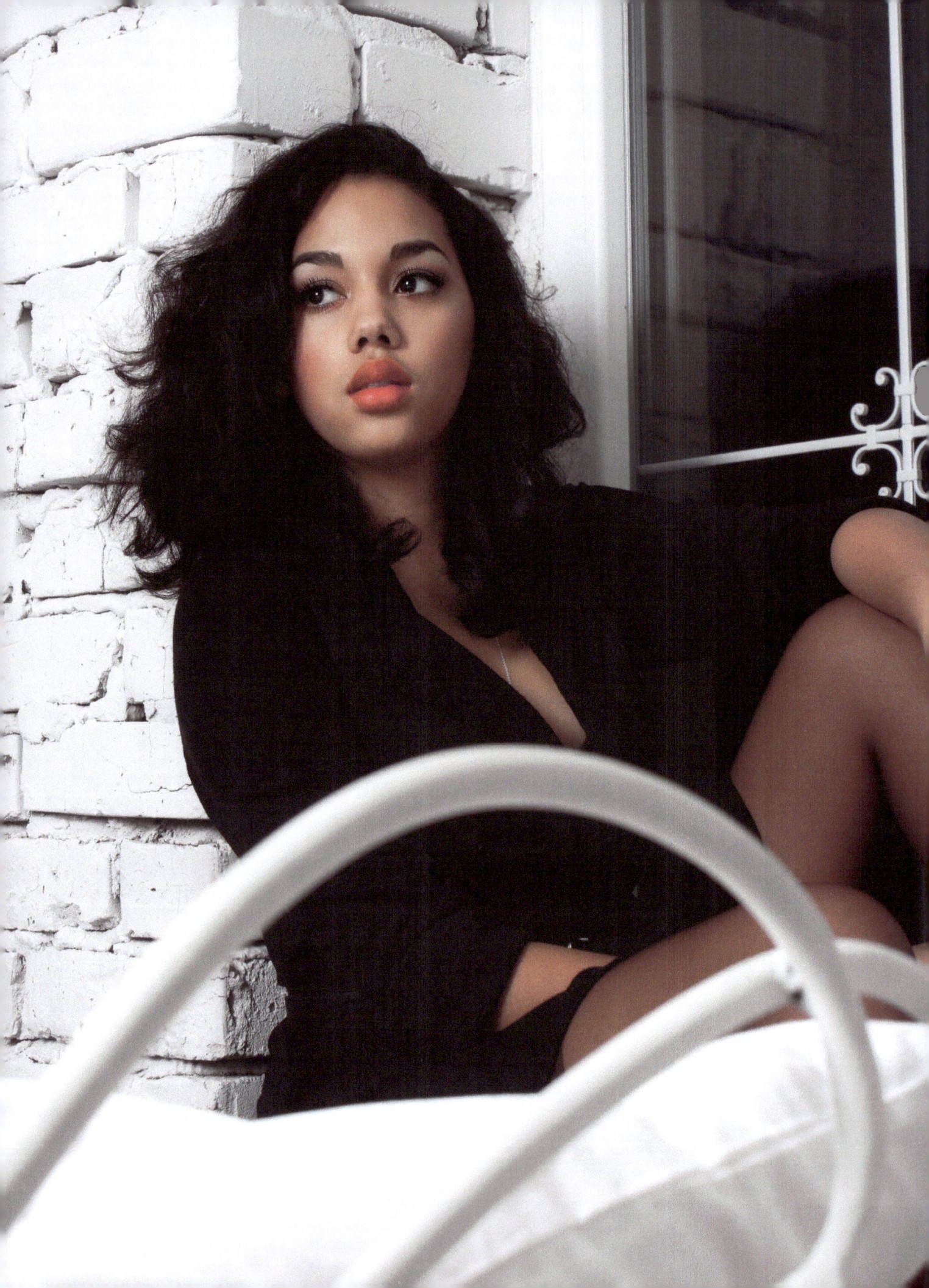

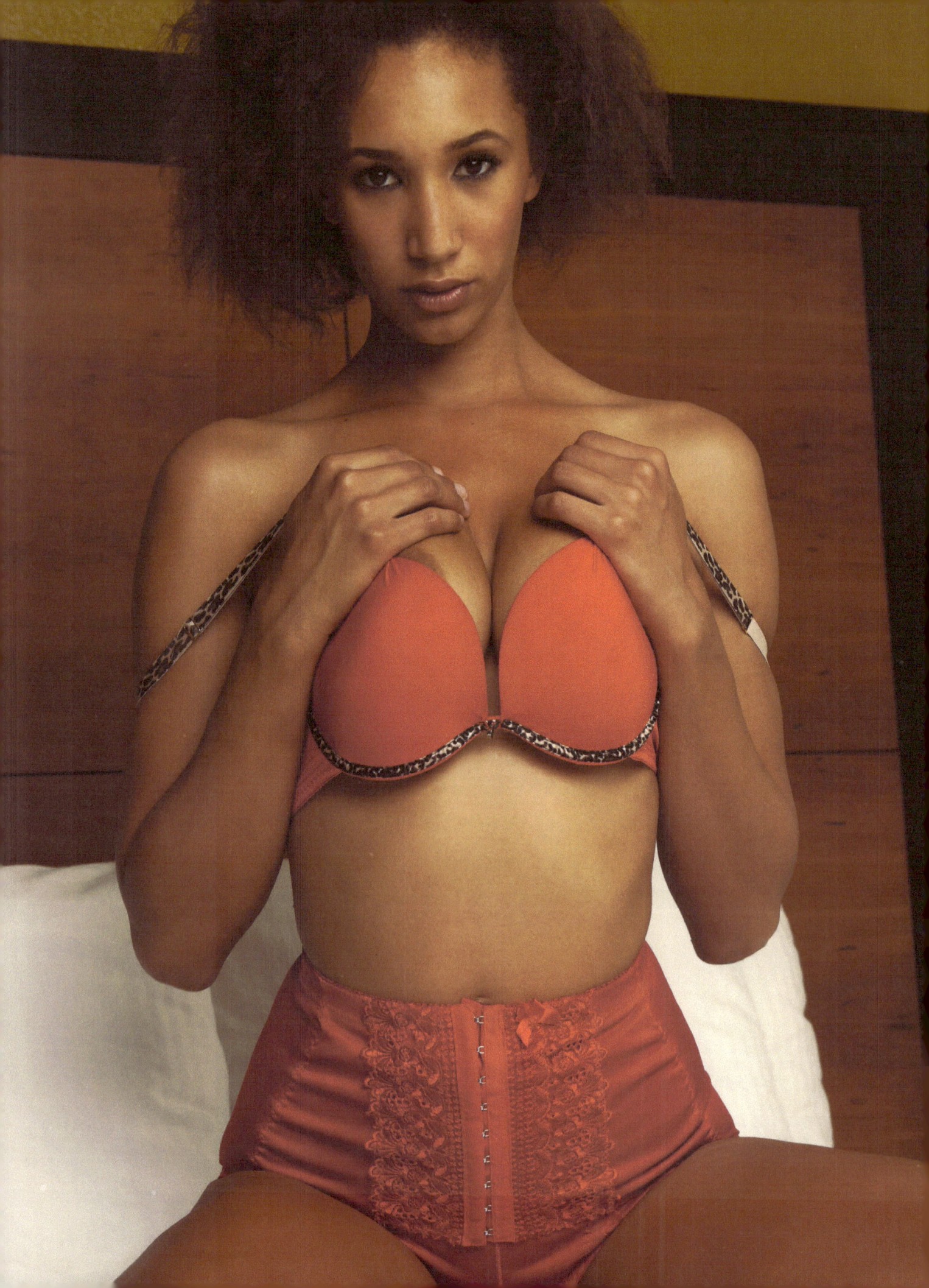

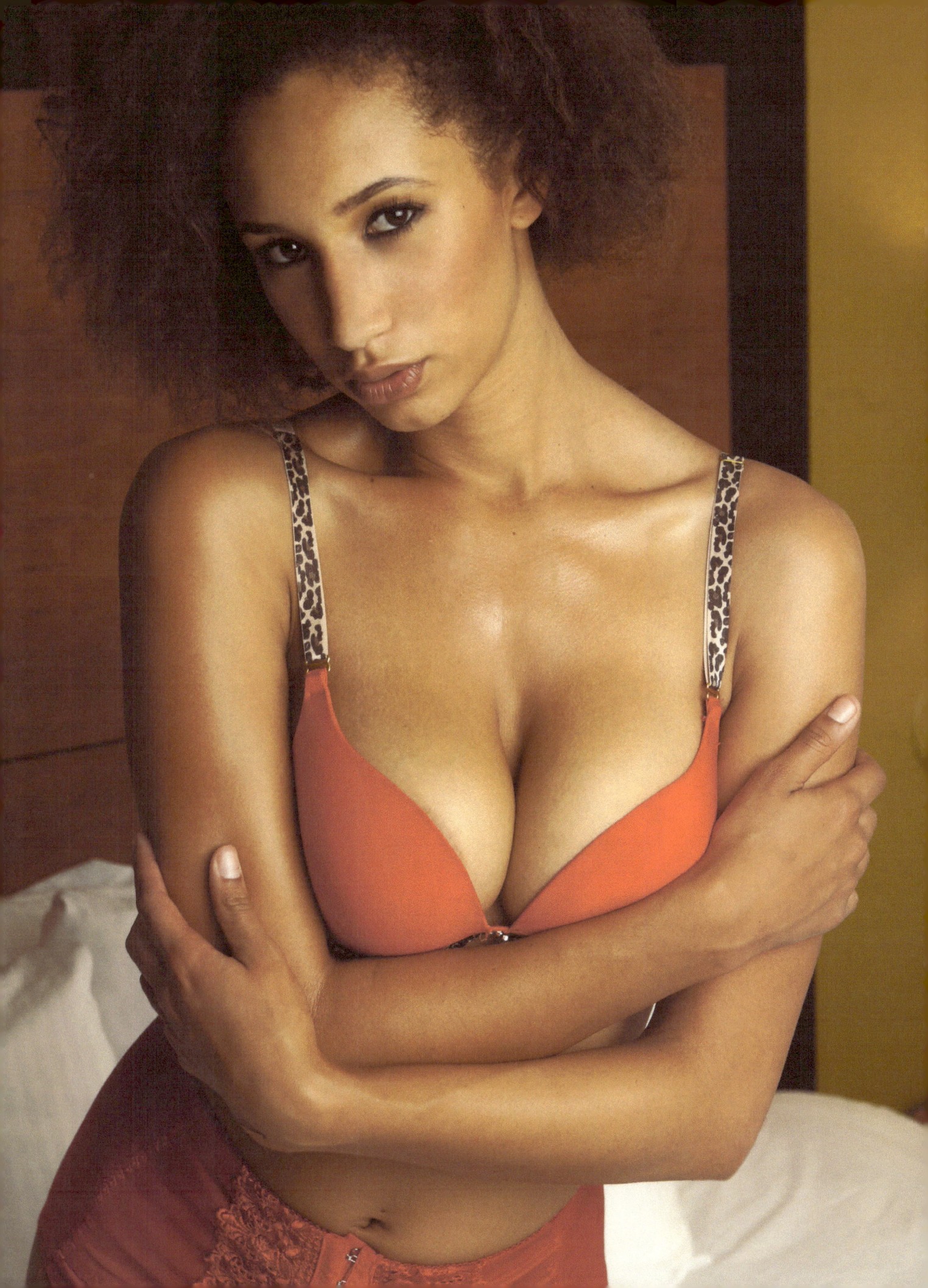

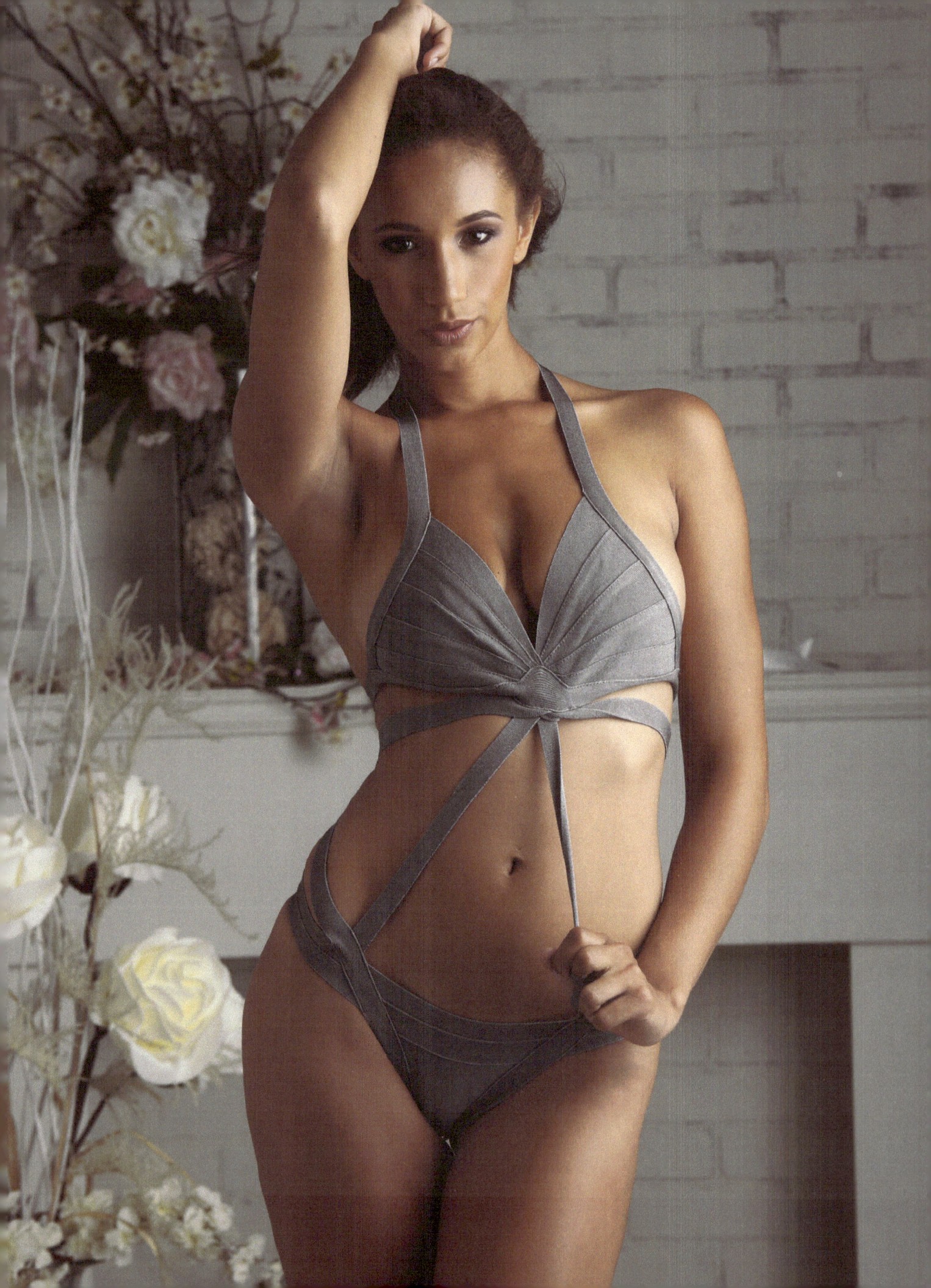

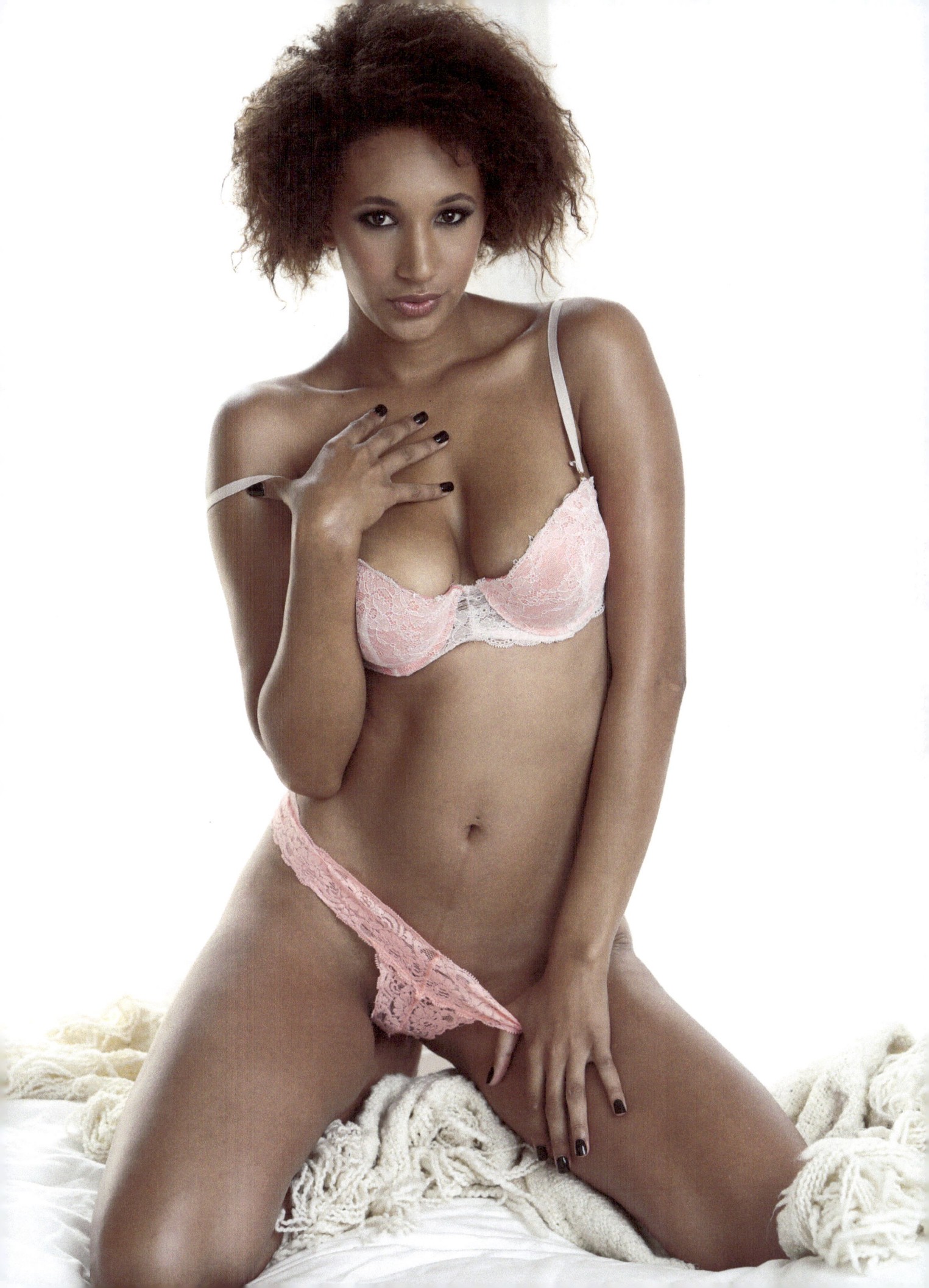

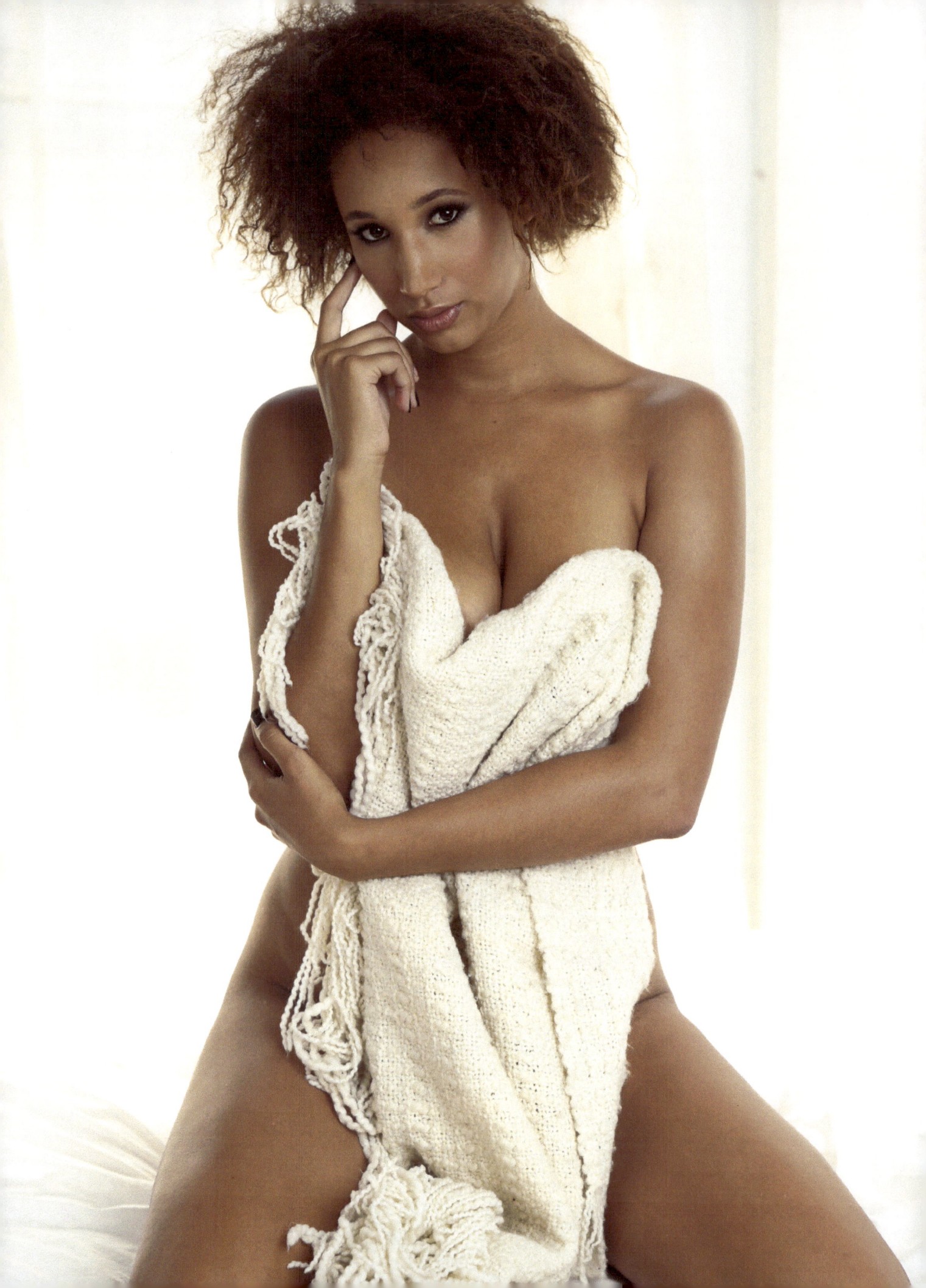

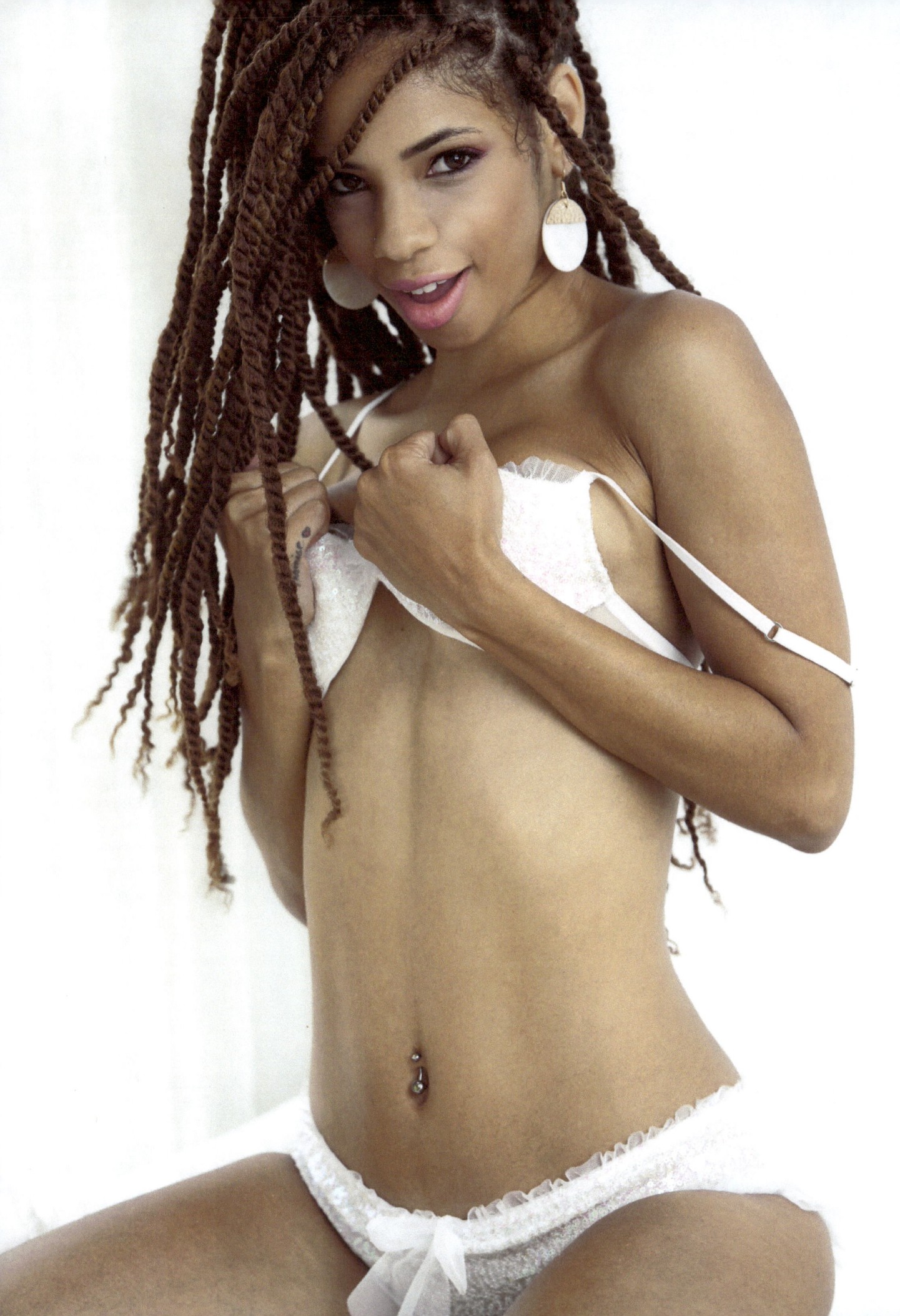

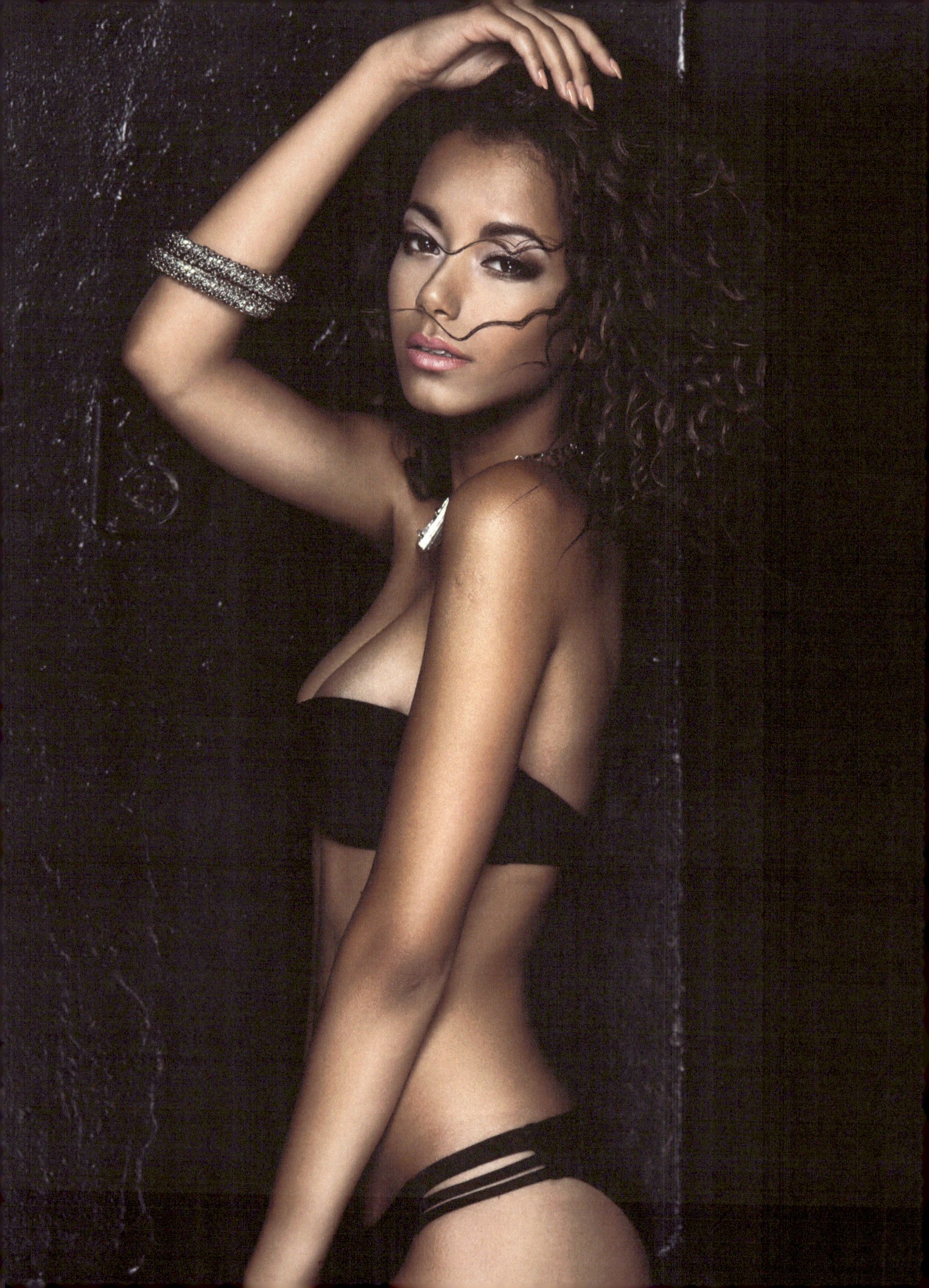

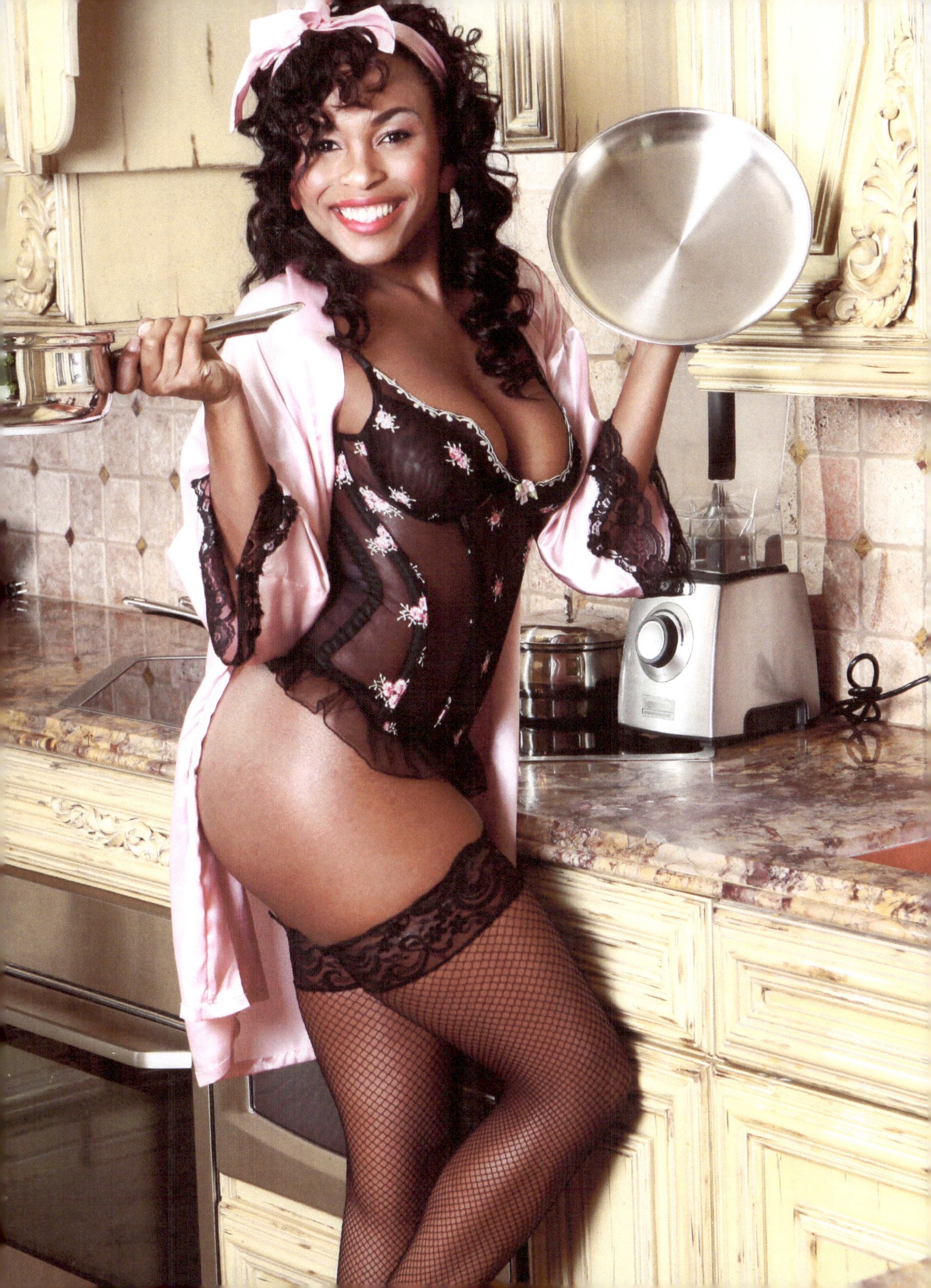

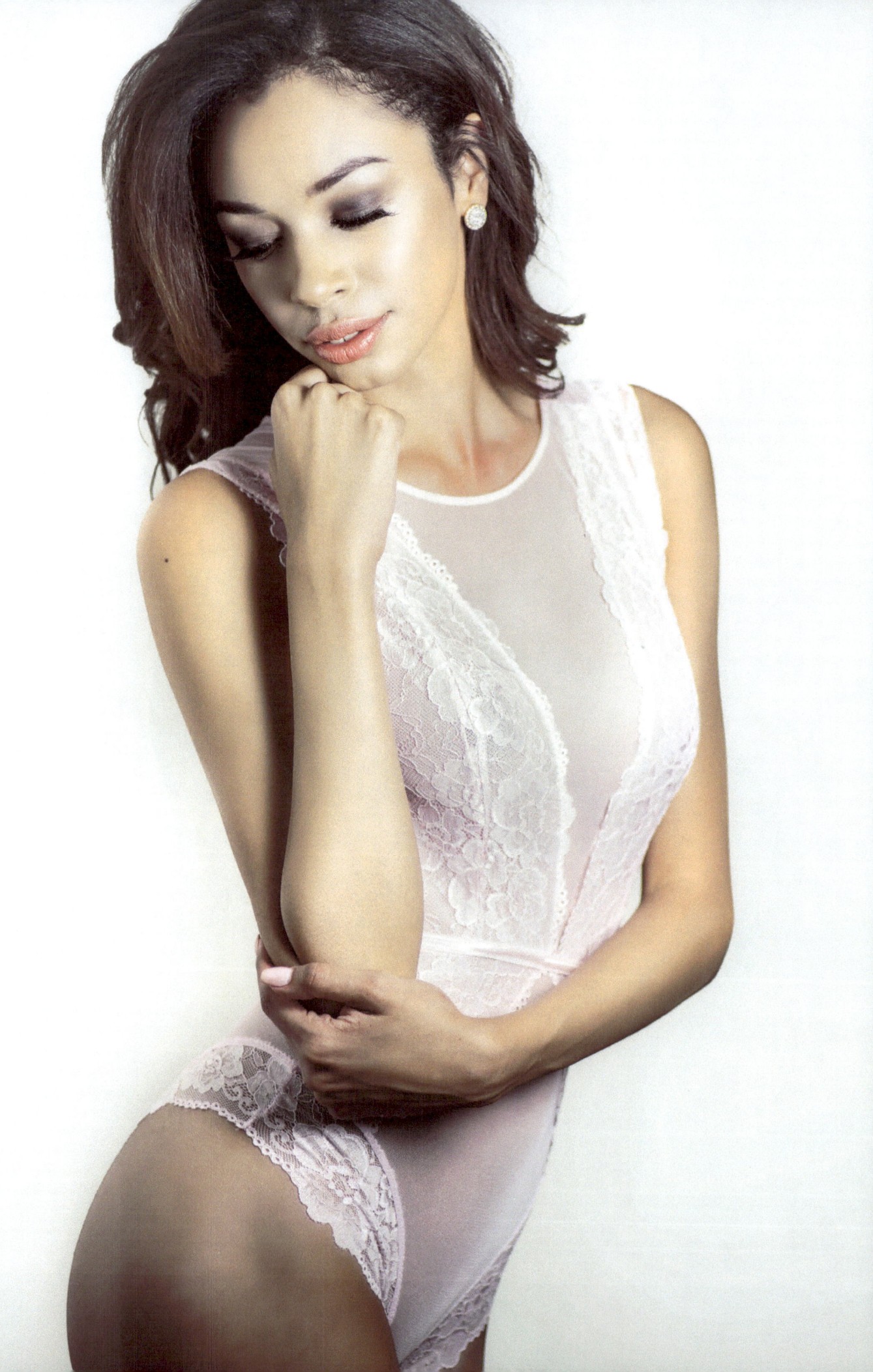

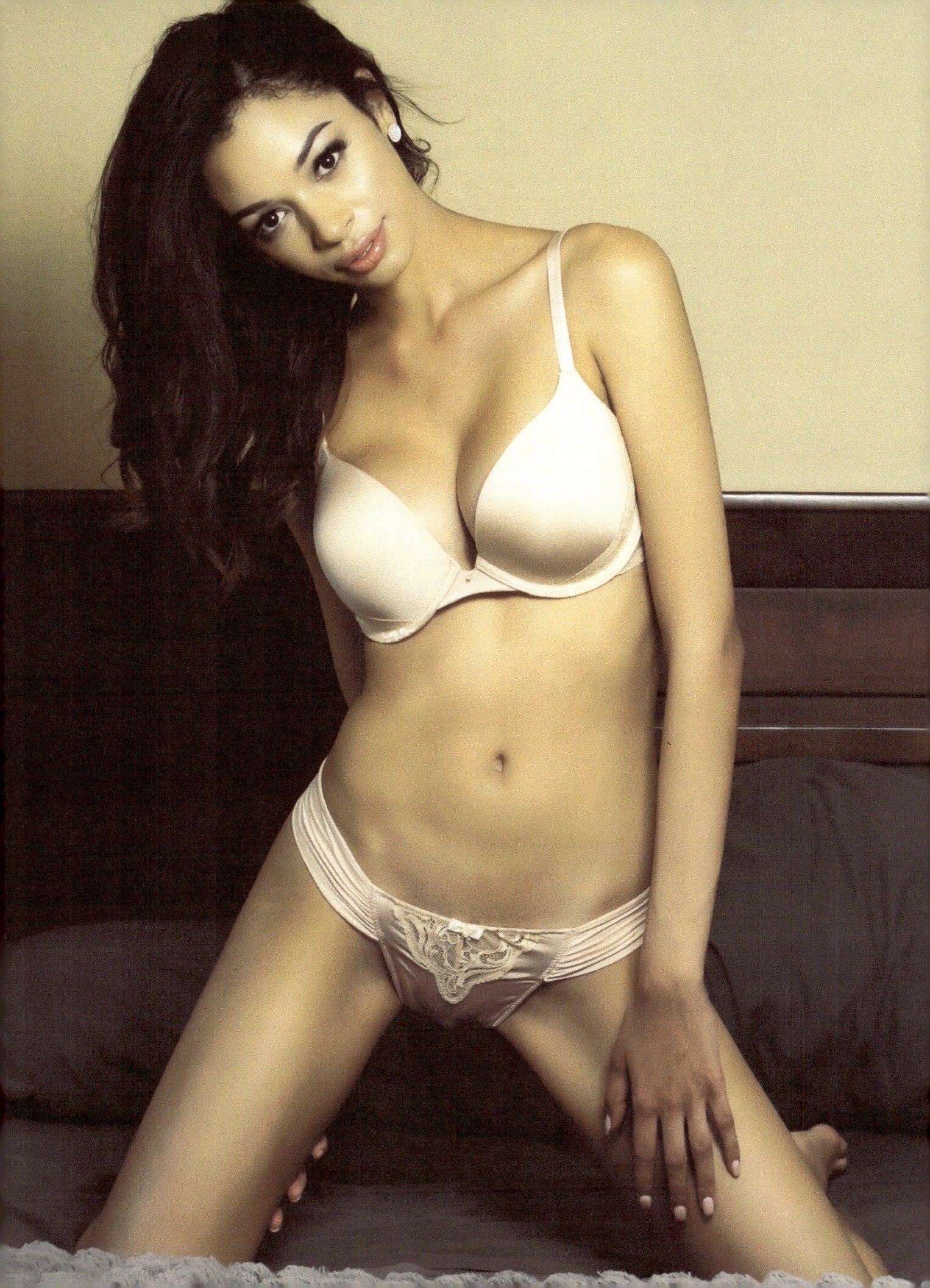

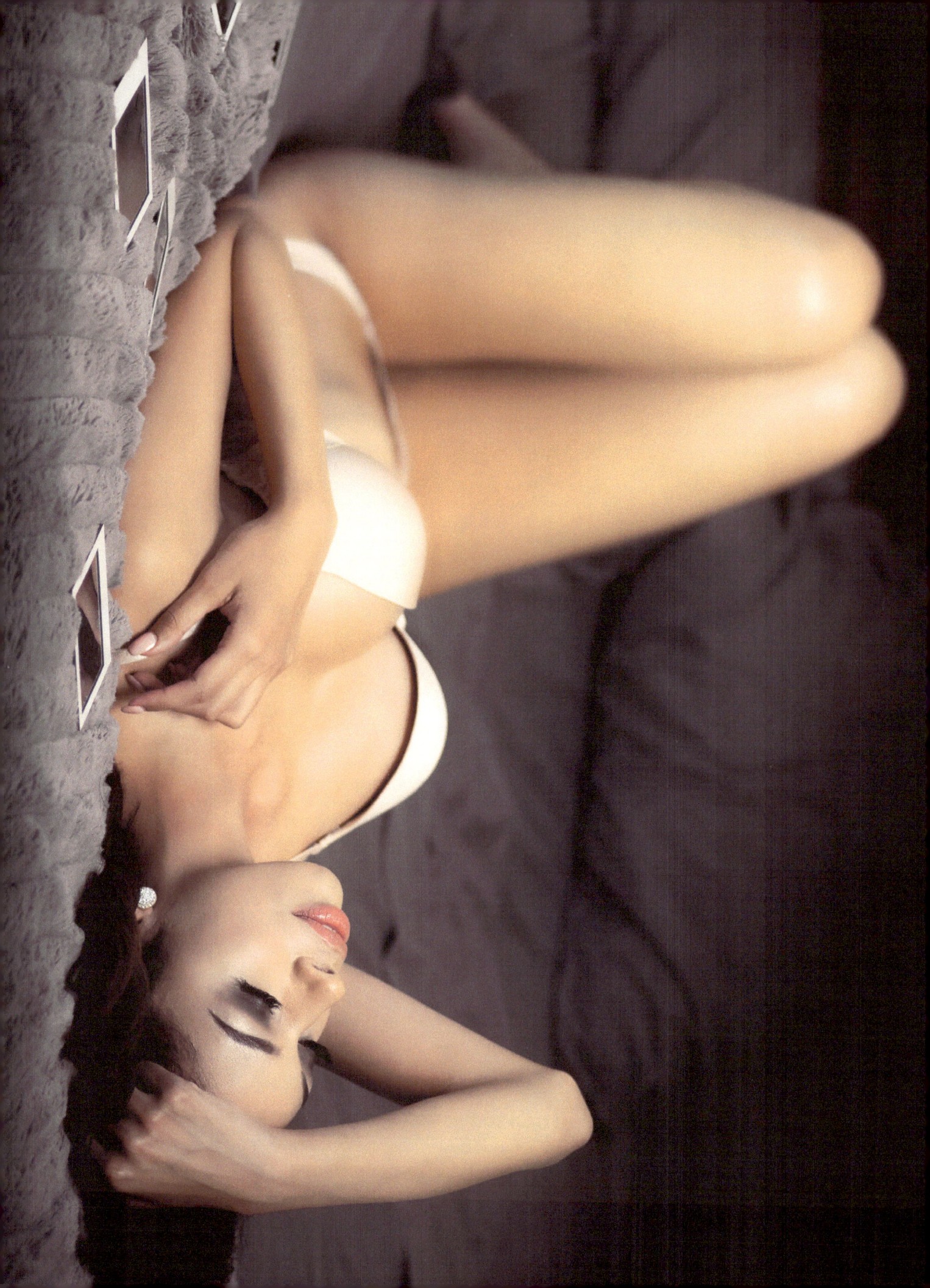

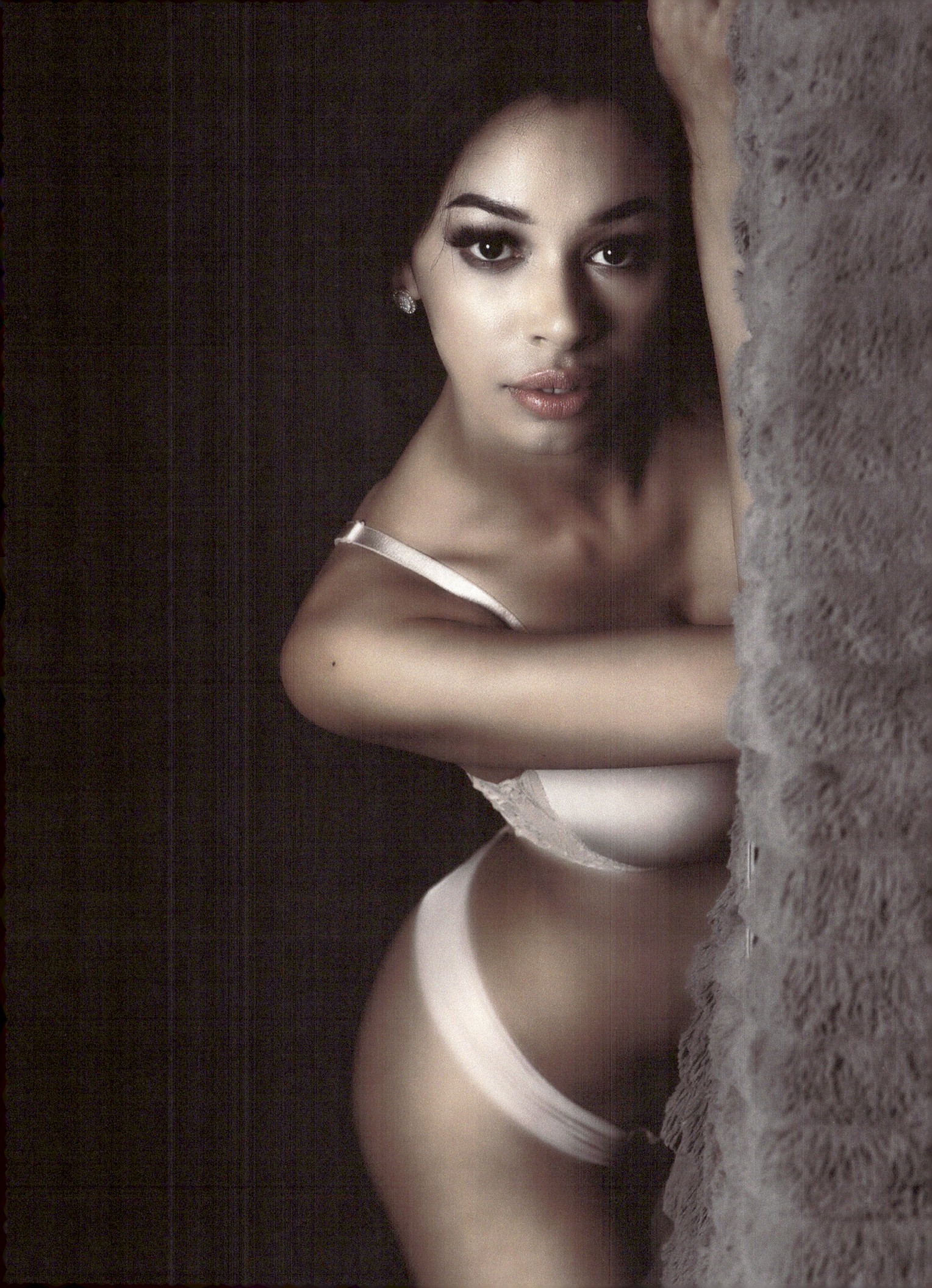

www.ingramcontent.com/pod-product-compliance
Lightning Source LLC
Chambersburg PA
CBHW050417180526

45159CB00005B/2314